intimate
portraits

intimate
portraits

Edited by Alison Lloyd

seren
Glynn Vivian Art Gallery

This book is a collaboration between seren and
the Glynn Vivian Art Gallery.

seren

seren is the book imprint of Poetry Wales Press Ltd.
First Floor, 2 Wyndham Street, Bridgend, Mid Glamorgan,
Wales CF31 1EF

Glynn Vivian Art Gallery
Swansea Museums Service
Leisure Services Department, Swansea City Council

ISBN 1-85411-153-1

The publisher acknowledges the financial assistance of
the Arts Council of Wales and
the UK Year of Literature and Writing.

Photography: Graham Matthews
Design: Simon Hicks and Alison Lloyd
Project concept: Keith Bayliss

CONTENTS

*This publication was produced in conjunction with
an exhibition originally held at the
Glynn Vivian Art Gallery, Swansea
29 April - 18 June 1995.*

Robin Paisey, Curator, Glynn Vivian Art Gallery
David Hoskin, Museums Service Manager
Daniel A. Minster, Director, Leisure Services Department

FOREWORD

The word 'portrait' is, to many people, evocative of those posed formal studies of the nobility adorning the walls of stately homes across Europe and beyond. Yet, portraiture in its broadest sense surely encompasses all attempts at depicting the human form, character and condition – a seemingly inexhaustible subject that has fascinated both artists and writers throughout history. **Intimate Portraits** incorporates the work of twenty-one artists and ten writers who were each asked to explore, re-interpret and re-assess this age-old subject through contemporary eyes.

Intimate Portraits was originally conceived purely as an exhibition. The Glynn Vivian Art Gallery (Swansea's City art gallery) approached twenty-one artists and asked them to produce a work that expressed a personal and intimate response to themselves and/or another person, and to accompany it with a brief written statement. The invited artists were selected to give a broad spectrum of responses, and therefore included both figurative and abstract painters and sculptors, a few known as portraitists but the majority not; the unifying factor being that they all live and work in Wales. All the works illustrated in this publication were on view within the exhibition at the Glynn Vivian Art Gallery from 29 April to 18 June 1995, most subsequently touring with the show to various venues in the UK and Europe.

As the launch of this exhibition coincides with the UK Year of Literature and Writing in Swansea, it seems appropriate that the accompanying publication should celebrate the hosting of this prestigious Arts 2000 festival within the City by incorporating the written word as well as the visual arts. We are delighted that, through collaboration with Seren, we have been able to include ten Wales-based writers, offering a similar breadth of responses to their visual counterparts.

The exhibition and publication share two primary aims. First, they seek to encourage a re-assessment of portraiture by generating a debate as to where the boundaries of the genre lie. Second, they are intended to highlight the strength of the arts within Wales. The artists and writers invited to participate are drawn from a group of individuals whose diversity reflects a true image of the healthiness of the contemporary arts produced in this distinctive part of Britain.

We are grateful to the Arts Council of Wales (Touring, Literature and Visual Art departments) and the UK Year of Literature and Writing for supporting **Intimate Portraits**, and to all the artists and writers who participated. We hope that this publication not only achieves the above aims, but also that it brings enjoyment to those who study it.

D. A. Minster
Director Leisure Services

the
writers

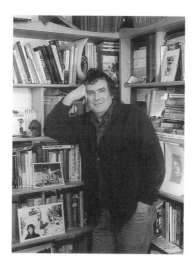

DUNCAN BUSH
The Face of Constance D.

Up in Arms the film was called. It came on the box one Sunday night when there was nothing much else on. It was made in 1944 and was Danny Kaye's screen debut, according to the TV Times.

It was one of those films Hollywood made for the War Effort. But by then the war must have been as good as won, because they slackened off the message and did it in musical comedy style. Liftboy loves the office girl. She likes him, he's a nice boy. But. She falls in love with the Other Guy instead. But Other Guy liftboy's best friend. Et Cetera. Danny Kaye plays the Hopeless Zany who loves the office girl, the screwball incompetent who does everything the wrong way round but everyone still likes him; you can't help it with a guy like that.

Anyway, the point is that the glamorous office girl who's fated not for Danny but for Dana Andrews, is played by Constance Dowling.

I don't suppose many people know who Constance Dowling is, or was. You wouldn't know her face if you saw it. I didn't. I had to look up her name in the cast list in the *TV Times*. And after that I couldn't take my eyes off her. It was a curious, belated and ambivalent encounter.

Constance Dowling was the actress Cesare Pavese was in love with. He'd met her in Rome, where she was on location for a film. This was in 1950, six years after *Up In Arms* was made. Pavese was by now a famous literary man, and that melancholy masterpiece *The Moon and the Bonfire* had just appeared. (The Italian edition still bears the dedication "For C. The Ripeness is all"). Another novel, *Among Women Only*, had just won the Strega Prize. He was at the height of his reputation and his powers. It was also the year that he committed suicide.

I've been interested in Pavese's work for a long time. I've translated his poetry, and he's a writer I've tried to learn from. About inwardness and indirection. And about ordinariness and subtlety: among prose writers, only Kafka is as ordinary, and as subtle, as Pavese. There is nothing quite like him in English. And there are days when it's as if that unique, disconsolate undertow of sadness that he has becomes your own.

So it was a strange experience for me to see, for the first time, this minor Hollywood actress that the shy, solitary writer had fallen so hopelessly in love with.

It must have been a desperate business from the start, Pavese never had much success with women, and this cool starlet who'd emerged to me from his diary and letters at that time seemed an unlikely, typically unlucky choice. "Choice" is the wrong word, of course, for a lonely and unhappy person like Pavese doesn't have the privilege of exercising judgement over whom he falls in love with. I

suppose it simply happens, and you suffer it. If the woman doesn't love you, all you can do is make a fool of yourself, or let her make a fool of you. And know that this is happening and that there's not a damn thing you can do about it. That's how it always had been with Pavese. It's only in a Danny Kaye film that all the false hopes and confusions turn out well, and the misfit gets the girl.

She was beautiful, of course: according to a certain heart-shaped Hollywood idea of facial beauty at that time, and in that type of low-budget, standard semi-hoofer, where everyone looks like a Goldwyn Girl. Anyway, she had what the later cliché calls Good Bone Structure. She wasn't wide-eyed, vacuous and scatty, and didn't try to play the part in that way. She wasn't a Mitzi Gaynor or a Judy Holliday or a Monroe. Instead, she had a strange serenity. Which I was glad of: I wouldn't want to think of Pavese conforming to the tragic stereotype, throwing himself away on a girl whose screen persona (or whose life) was no more than a dotty platitude. She was wearing a little too much, and a too-red lipstick, possibly. And the inflexibility of her hair-do made her seem to be bearing it consciously, like some ornamental helmet. But this, again, was the cinematic fashion then. The colour wasn't too good, anyway: even Danny Kaye seemed to be wearing lipstick in some scenes, though of a subtler shade. As for his hair, it shimmered between old gold and a pale, unlikely orange. But then, it always does. It was that period of early colour-stock where reds and flesh-tones have a slightly hyper-real quality - like in the tinted stills in the foyer - while other colours (foliage greens and browns and darker shades) always turned out matt and drab.

It was perhaps for this reason that it was hard to tell what colour Constance Dowling's eyes were.

She had fine eyes, a lovely flashing gaze. But they might have been brown, or hazel, or even that dark unusual cobalt blue some eyes are. I suppose she wasn't a big enough star, famous enough a beauty, to rate the full-face close-up that would have shown them properly.

Even her eyes, then, were ambiguous. As they had been for Pavese, at the end. "Death will come, and it will have your eyes", he had written in that beautiful, desolate series of poems published after his death, and which were his final testament: testament of his hopeless love for her, of his whole unhappy emotional life, and of his long contemplation of the possibility of suicide. Before that night in August 1950, when, under an assumed name, he hired a cheap room in the Hotel Roma in Turin to do it in.

Death will come, and it will have your eyes -
this death that goes with us
from morning till night, unsleeping,
frowstily, like an old remorse
or some dull vice. Your eyes
will be a pointless word,
a cry suppressed, a silence.
As you see them every morning
when alone you lean
into the mirror.....

What became of Constance Dowling? Six years after *Up In Arms* is made she meets Pavese. They seem to have had a brief relationship that might have held days, or nights, of happiness for the both of them. But only her diary could tell us how she felt. As it is, we only have Pavese's. And from that we do not even know if they slept together: the terseness of its final entries is such as to perform the office of discretion to the prying, necrophile gaze of speculative hindsight.

Who knows? These things might be established by a biographer. And perhaps not. Life is composed of mostly small events which vanish almost as soon as they occur. Circumstances from another person's time on earth emerge vicariously for a moment out of silence, then sink back into it again. Life goes on for those still living. The film ends. Dana Andrews gets Constance Dowling. Danny Kaye gets Dinah Shore.

Forty years later the film is shown on Channel 4 one night. Kaye, the manic comic - an intropunitive self-violent type if ever there was one, you'd have thought - is still alive, presumably out in some wealthy Californian suburb. Dana Andrews, an underrated actor who did a few good films, professionally ended up doing grey-haired elder statesmen cameos in disaster movies and died the other month. Dinah Shore and Constance Dowling may be plump great-grand-mothers surrounded by family, or dead, or living on Valium in some sorry rented room, victims themselves. Even the girls in the chorus line all have their own histoire d'amour... but we'll never know exactly what it is, nor how it all turned out. All that ever happens is that the living go on doing that, having little choice - and, in the majority of cases, wanting none.

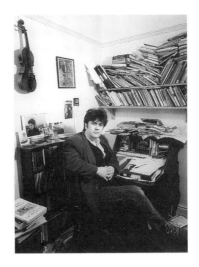

PAUL HENRY
Daylight Robbery

Silent as cut hair falling
and elevated by cushions
in the barber's rotating chair
this seven-year-old begins to see
a different boy in the mirror,
glances up, suspiciously,
like a painter checking for symmetry.
The scissors round a bend
behind a blushing ear.

And when the crime's done,
when the sun lies in its ashes,
a new child rises
out of the blonde, unswept curls,
the suddenly serious chair
that last year was a roundabout.

All the way back to the car
a stranger picks himself out
in a glass-veiled identity parade.

Turning a corner
his hand slips from mine
like a final, forgotten strand
snipped from its lock.

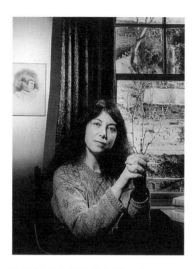

HILARY LLEWELLYN-WILLIAMS

A Nun in the Dunes

This woman has chosen coolness.
It fills her from toes to skull
an inner pool. It's behind her eyes
her pale coiled hair. The touch
of her hand is cold water.

A calm wind blows through her,
curls from her pores. She pulls on
flawless red boots. Fresh as rain
falling through leaves in a walled
garden, she's clean as dew

that appears all at once, a miracle
on the grasses. What she takes
in, she cools and stills:
the warm world, pressed in its frost
of linen, its iced silks.

She walked with us in the dunes
in the narrow sun of a winter
afternoon – a grace
without heat, being light only.
And being new to this place

she glanced round, birdlike,
at the hills of crushed shell,
spiked sloe and buckthorn, rags
of heather, and caught them all
to be smoothed, and folded.

I think she loves this weather,
the brief bright days. She could stand
on a mountain over the world
and wave a sword. The land
would fall in dunes like this.

We climbed a hill, stared out
over rainfilled slacks and gullies
to the sea. And God shone
in a cloud, descending to the bay
in rays of pale gold.

She took a picture, froze
the vision. Later she'll look
at it, framed in grey
on a white wall. She won't mind
leaving the dunes behind;

it's what she's chosen.
Cool air stirs round her
like a veil. I burn beside her
in my usual fashion:
my choice, my blazing grail.

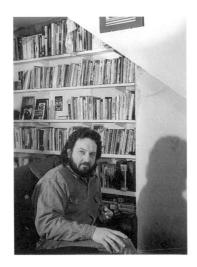

NIGEL JENKINS
Portrait of a Collector

His friends, he called them.
Not that he'd actually talk to them, these
priceless paintings of the urban poor
– nothing, good lord, sentimental like that –
but they brought him a sense of, well,
comfort almost: the frugal meals of these people,
their pictureless walls, those hands
with scarce the strength to wield a spoon:
he wasn't, they implied, the only one
to be lonely in the world
– which he felt, o yes, just once in a while.

And those empty gazes,
the way that their eyes seemed never to meet
the eyes of another; the way they appeared
unspoken to, unspeaking, even
among themselves, unable, it seemed,
to do a single, simple thing together.
Rootless and yet ... immobilised.
On these walls, in this house.
That was also, perhaps, in a curious and in-
definable way, not without its
consolations.

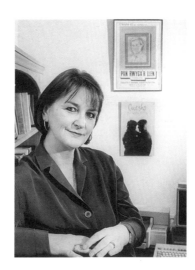

MANON RHYS
Cysgodion

In my novel *Cysgodion* (Shadows) Lois Daniel is an author who is writing about Gwen John's long, passionate and all consuming affair with Rodin. But she herself becomes a shadow of Gwen as she becomes more and more involved with her own lover. Her complex hangups both sexual and psychological are exposed throughout the novel.

In this extract, Lois attempts to convey the erotic intimacy between Gwen and Rodin during a modelling session for Rodin's *Muse*. Lois' interest (and mine) lies in the fact that Gwen John, an artist, chose to be a nude model for another artist. Why? Because she needed the money; because she felt honoured to be a part of the master's great work; because she yearned to be kneaded like clay in his hands.

But most of all, because the timid, introvert 'mouse' of a woman was besotted with the extrovert, flamboyant womaniser.

Extract from *Cysgodion*

The pleasure of standing naked in front of him makes her face glow much more than the dozens of candles dotted around the studio. The pleasure oozes out of her, and flows over her body like warm wax.

She stands two paces from him, gazing at him as he fingers his white beard, his dark eyes measuring her, inch by careful inch.

He snaps his fingers and one of his 'assistants' sets a block of wood at her feet. Having studied her again for long minutes, he approaches her and positions the block carefully by her left leg. Placing his hands tenderly under her knee, he lifts her leg slowly, and rests her foot down on the block.

He steps back and looks at her.

Then he picks up a white shawl of smooth silk and throws it over her knee. It clings to her leg with its deep pleats falling to the floor.

Standing back from her, he looks at her again.

He comes to her and pulls her leg an inch higher, an inch wider, readjusting the shawl carefully between her legs.

As he runs his forefinger up and down her backbone and massages her shoulders and the nape of her neck, she relaxes like a rag doll, softening like clay under his fingers. Slowly and tenderly, he pushes her shoulders down, and down again, until her breasts brush her knee.

He looks at her yet again.

His hand fondles her face as he turns it this way and that to catch the light. He fingers her cheekbones and nose, and touches her open lips. With his other hand, he pulls back her hair from her forehead, combs it through his fingers, then spreads it like a fan over her shoulders.

He steps back and stares at her for a long time before coming to her again and turning her face a shade towards him. Then he smiles at her, and she returns his smile.

She feels the old, familiar stirring between her legs; a stirring which reminds her of the touch of smooth silk ...

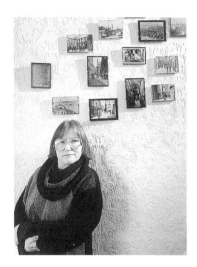

SHEENAGH PUGH
This Basement Room

This basement room. No sun gets in.
Its walls are soundproof. Outside,
the air reeks of fish; a raucous scrum
of gulls goes down on the harbour scraps,
and your wife's shoes clatter on the flags
as she hums your tunes. You wouldn't know.

The light slips by: six hours a day
in the northern winter. July nights
will be blue, uncertain; sun dawdling
on the sea's rim, no-one going to bed,
but you know you'll be dead by summer.
This basement room: hour after hour

you make music. The blank tapes fill with tunes,
tunes that waited, these many years,
while you ran the laundry, drove taxis,
fed your family. You're no Gauguin;
you were too good a man to be free.
The light slips by, but what is left,

all your life, now, belongs to you
and your fiddle, and its loosed voice.
One bright morning, you felt guilty:
asked your wife if she'd like to go out,
spend time with you, and she answered:
"You make music: I'll bring food."

Your death coming set you free.
For all the pain, your bow-arm
flexes easy as ebb-tide
over the notes; easy as a man
coming home after years away.
All your life, you wanted this:

this basement room. The waiting tunes
belong to you, and all your life
fills the blank tapes. She brings you food
and sets you free. For all the pain,
she hums your tunes. The light slips by.
Your death coming, you make music.

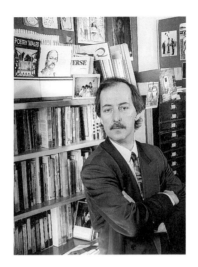

LLOYD REES
Eye of the Beholder

He can't even stand still. There's a leer a thousand years old on his collapsed mouth. His lips are wetted, have taken on a glaze that has disappeared from his unsteady eyes; a shine which seems to have moved south to the bibulous nose too. The cab driver had to switch off his engine, so long was he locating his trouser pocket for the screwed up ten pound note there. Then even after the deliberately slow counting out of the change he had continued to sit slumped in his seat. It had taken him several passes at the door handle before he had managed to pull himself out of the taxi. The driveway and then the short stretch of lawn to cross before he arrived at his front door were an Irish Sea in February. A tell-tale crunch had reduced the garden's snail population by one.

He puts out a hand to steady himself but it misses and he has to step backwards and butt up against the woodchip wallpaper of the hallway. A smile nudges the leer off his face.

"How're you doing?"

There is no reply.

This man has had a good time. Once. Not tonight though perhaps. The lines gouged out beneath his hangdog eyes by the trowel of the years are river beds for sweat. A six hour bristle is pushing through the banks of his cheeks, darkening the red and grey landscape. A hand veers up to push at the overhang of drink-lanked hair, then smear down the stubble. The knuckles are bruised. He is surprised and sorry for the hand: it has only been fighting time, not any more real opponent. He licks at a drip of blood on the knuckle like a cat at a half-felt flea and the arm falls away again.

He examines his shirt. It is damp. The early morning dew of spilled beer has flattened a patch above his heart; otherwise there are more creases than if the shirt were made of crushed silk, which it is not. There are dog hairs on his jacket, though he has been nowhere near any dogs tonight. He picks one off, after a few attempts, to scrutinise its blonde sheen. It falls from his fingers and re-attaches itself to the jacket. He fumbles in his trouser pocket and pulls out something. A note. He holds it up and smoothes out the crumples.

It is still limp, like vinegared paper. He tries to read its denomination and then exhales like a horse when it is only five pounds.

"What happened to dapper?" he mouths at the darkened mirror before him. It comes out more as "wnambdadabba". A fridge starts up and causes him to spin even more than he presently feels he is doing. His hand has involuntarily formed a fist to ward off or bludgeon this cool intruder. He turns again to the mirror and smiles urbanely: "Star sbreadin the nooze," he sings. He is Ol' Red Eyes at

Carnegie once more. Dapper as a tuxedo. Dapperer than a Freemans catalogue.

Once, a thousand mirror-concerts ago, he would have loosened but not fully undone a tie, fallen into the arms of a chair by the unlit fire and fallen uncomfortably but indefatigably asleep. Now, deep into the second half of our marriage, he knows with dormouse certainty the softer contours of the big bed upstairs. He looks longingly up the shadowy stairs but doesn't move. He is beer-glued to the spot, suctioned on the threshold of out-for-the-night and back-for-the-night, too tired to make himself a nightcap and too thirsty to go without. He farts long and echoingly.

I feel all sorts of sorry and all sorts of disappointed for him. He has been in this state before. With more regularity than I care to admit. But he is capable of other states. He can be tender, trite, touching; amazing and dull; brilliant and comfortable. Astonishingly, he can be all of these at the same time, it sometimes seems. He is staring at me now as if I am the fridge, walked in from the kitchen to threaten, or a stranger whose house he has unforgivably intruded. In the dog-plaintive expression there are questions sent skimming and surfing from the lachrymal ducts across the blue of the iris and the red of the white of the rest of his eyes. "How did I get to be here?" is the gist.

Then he notices the photography on the wall beside the mirror. It is a mock-Victorian sepia seaside job of us dressed up as a moustachio'd young man and his tight little parasol'd wifelet. He is seated in the foreground, she is standing with one dainty hand resting on the wing of his chair, dutifully at his shoulder, respectfully at his rear. We are staring into the middle distance of nineteenth century certainty and moral rigour, a view of a country garden embroidered on flock behind us which flaps in the breeze that has entered the seaside photographer's canvas stall. He looks older then than now, such are the knuckles that he rests on his cane and such is the force of his whiskers.

And that he is still me. I'm that and I'm this, I realise. I co-exist. It is me in the picture. It is me in the mirror. It is me, sober inside this mumbling, fumbling bag of clothes and weak-kneed bones, and it is me also, drunker than that funeral or even that wedding. I am standing, or leaning, in my own hallway waiting for my untight, unparasol'd wife to appear at the top of the stairs and shout at my lack of rigour, my lack of self-discipline in allowing myself to be carted off to the tip of another drunkenness. If she does I will leer. If she doesn't I will smile. Tomorrow is time enough for tender and trite; for now I'm enjoying this McGill postcard of myself. I'm smiling again at that intimate stranger that the mirror can flash at my childish eyes like a prestidigitator, though I still can't work out the trick.

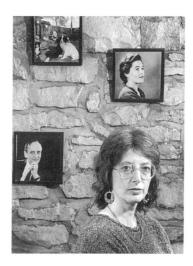

CATHERINE MERRIMAN
Blue Pastel Woman

Let me describe the picture. It is of a young, naked woman lying on her side on a sheeted double bed. She is propped on one elbow, her body facing us. Her thighs and lower legs are together, her knees slightly bent. A touch of mermaid.

The picture was drawn 24 years ago, in dark blue pastel on a large sheet of white cartridge paper. Pastels or charcoals were the young artist's favourite medium – they suited his cavalier, broad-stroke, almost slap-dash style – but neither artist nor model can remember now why blue was chosen. Very possibly, since at the time the artist only drew for pleasure, having abandoned formal training some years before, the blue was simply one of the few sticks in the pastel box left unbroken, or of sufficient length to use. Whatever the reason, it is a strong, attractive blue, not at all cold, and can be seen now, since blue is the colour of time, to have been a good choice.

So; the model lies across the bed at an oblique angle to the artist, her head nearest him, her body trailing away from left to right. Her naked figure is sketched with great confidence and conviction down to her knees, but beyond this we sense the artist's interest flag; the model's furthest extremities, her toes, are only cursorily sketched, with wrist-flicks of short blue lines. A suggestion of fused fin, almost, rather than feet; reinforcing the lower-body mermaid impression.

Although the model, overall, is average sized, with a flat young woman's abdomen and slender arms, her breasts are large. They are pendulous and look soft and round and entirely natural. The model remembers being told by a male acquaintance, some time before this picture was drawn, that the perfect female breast fitted exactly inside a champagne glass. She remembers mocking this pronouncement. The breasts in the picture are more wassail-cup than champagne-glass sized. You sense however that whatever ideals may have prevailed when the picture was drawn – and a boyish skinniness was undoubtedly fashionable then – the artist had no reservations about the size or shape of his model's breasts. The model, even now, after 24 years, can remember her own youthful body and admires the accuracy of his drawing. We feel, indeed, quite strongly, from the centre stage position given to the woman's upper torso, that both artist and model must have been comfortable with the flesh as it was.

The model's face, interestingly, is not visible. She is looking away from us, towards a point somewhere the other side of the curved mound of her hips. Towards her left arm, perhaps, which is draped across a sketchily-drawn plumped-up pillow behind her. All we see of her above the shoulders is her hair: thick, long, ungroomed tresses, possibly fair, which fall almost to the point of her supporting elbow. It is the clumped, slightly damp-looking hair of

someone who has just woken, or just bathed, or, possibly, just unentwined herself from someone else.

We know the model is aware of being drawn, because of her arranged, mermaid-like pose, and there is, therefore, despite her turned-away gaze, no sense of voyeurism in the picture. What we do sense is that the model felt no need to watch the artist at work, or indeed, attend to the creative process at all. As if she trusted the artist and her body to have a direct rapport, without mediation or supervision by herself. And as if confident that between them, left alone, body and artist were capable of capturing and expressing the whole of her. Perhaps the picture, paradoxically, expresses more for the very lack of a face. Faces are never bland slates and always attract the eye. This body expresses total ease, precisely, one feels, because it does not watch the artist, and its focus is diffuse. And the artist, for his part, draws what he sees, under no one else's eye, as and how he pleases.

This drawing, though it has existed for 24 years, has been viewed by no one except artist and model. It has never been mounted or hung, and although it has charm, it is of no artistic merit. Neither artist nor model, at the time, expected otherwise. It was the act of drawing the picture that was the event; the pastel-on-paper result was merely the memento of that event. And the drawing only exists now for the same reason that any household memorabilia exists:

it was durable, has been kept in a sensible place, and no accident has befallen it. And, of course, no one has been moved to deliberately destroy it. Deliberate destruction would be meaningful in a way that simple retention isn't.

So where is it now, this drawing? Well, this picture, of a young woman lying naked on her first marital bed, sketched by her young husband one hothouse afternoon 24 years ago, is kept, along with other early sketches, under the same couple's present marital bed. The couple did not put it there for any significant, symbolic reason; the floor under the king-sized divan was simply a safe, convenient spot for storing a large, flat, rarely-opened portfolio.

Nevertheless, both artist and model know that the picture is there. And because they know this, just occasionally, while lying above it, they recall it. The blue pastel image has taken on, these days, in both their minds, a talisman quality. A quality never intended, but perhaps inevitable. It has been a long time. The artist, over the years, has forgotten now to draw. The model is no longer longhaired, or youthful. And yet the originals are still there, underneath; look, there is proof: blue pastel woman and her artist, not an arm's length away.

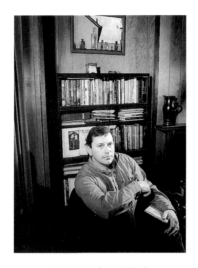

TONY CURTIS

Portrait of the Painter Hans Theo Richter
and his wife Gisela in Dresden, 1933

This is the perfect moment of love –
Her arm around his neck,
Holding a rose.

Her wisps of yellow hair
The light turns gold.
Her face is the moon to his earth.

Otto's studio wall glows
With the warm wheat glow
Of the loving couple.

This is after the dark etchings,
The blown faces. This is after Bapaume –
The sickly greens, the fallen browns.

She is a tree, her neck a swan's curved to him.
His hands enclose her left hand
Like folded wings.

This is before the firestorm,
Before the black wind,
The city turned to broken teeth.

It is she who holds the rose to him,
Theo's eyes which lower in contentment
To the surgeon's smock he wears for painting.

This is the perfect moment,
The painted moment
She will not survive.

This is before the hair that flames,
The face that chars. This is before
Her long arms blacken like winter boughs.

This is the harvest of their love,
It is summer in the soul,
The moment they have made together.

From Otto's window the sounds of the day
The baker's boy calling, a neighbour's wireless
playing marches and then a speech.

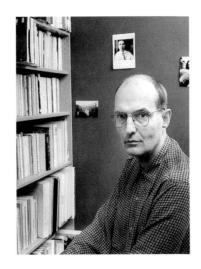

PETER FINCH

Intimate Portrait

potor fnich
pitar fnoch
petur fnech
pootr fnach
polet forch
polit farch
petit frech
pomer frish
piler frash
petot fansh
pitur fensh
peeti finsh

Rain Man

I am in the rain, it always rains
 it doesn't bother, I like to think so
I am in the rain arguing, rain got in,
 hard to function
I am hollow rain, echo of rain
 all rain echoing each rain like this
 all like Einstein's cylinder
I am all echoes each echo every echo
 all of them
I am trying to be all these things
 and it works sometimes
 and sometimes there is silence
I am approaching now something which I have
 already done all done but this
 approach it is different. Like the sky it is the
 same sky each time I look and each time
 I look it is different
I am about to do this I am Heidegger uncertain
 part Buddha nature each rain sibilance all fog
 of Fnich each step the start of 10,000 miles
 doesn't matter one 10,000 rain then another
I have been here before rain and echoes
 nothing new it is that simple·

PETER FINCH
Exhibition

Man With Towel Drying His Tongue
oil on canvas
30" x 20"

Bright Nude With Crown pastel
on paper
10" x l6"

Self-Portrait With Star On Stick
mixed-media
40" x 60"

Triptych - Nudes Embracing, Nudes Struggling, Nudes Parting
oil on paper with felt roofing strips
30" x 8 yards

Self-Portrait With Stick And Ripped Shirt
pencil
2" x 2"

Portrait of The artist As A Misogynist,
tongue between teeth
oil on canvas with eyeliner applique and
glued beer cans
collection R. Brody

The Passage Of Time
mixed-media - tin bath, grey water, 50s television set with
the plug removed

This Is How It Is Now
instamatic assemblage of artist looking miserable
in various parts of the city
40" x 30"
collection R.Knowles, private investigator

Untitled
body tattoo "I Love You" crossed out with blue biro
NFS

Small Man With Bottle
charcoal on burned paper
10" x 10"
collection the artist.
Print available, enquire at desk

Dark Curtain
(hangs over door)

the
artists

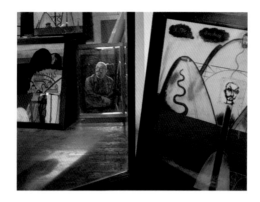

IWAN BALA

In my belief, artists who work from the pure imagination, or who allow their imagination to intervene in the depiction of 'reality', are involved in portraying themselves in one way or another.

My work has dealt directly or obliquely with events, experiences and memories of my life. The paintings and installations are a form of inner self-portraiture, in that they are autobiographical, re-created memories.

Recently I have been working on a series of "imagined landscapes", stylised mountains, rivers, islands and seas. Strange yet familiar, these landscapes also bear resemblances of the human form, particularly the rounded belly and raised knees of a pregnant woman. Landscape painting has often claimed this reference within itself but it will come as no surprise to learn that at the time of writing this my wife Sophie is a month away from giving birth.

The Welsh title "*Y Tir Beichiog*" refers to this. However 'beichiog' translates as 'burdened', i.e. carrying a weight, rather than the weaker English 'pregnant' or 'expecting'. In this work, the landscape/woman is 'bearing' the weight. The male protagonist (always myself) merely looks on, but is nonetheless centred there in his mind (his head being there at the place of birth).

There is in the picture also a fragment from an earlier work, an imagined landscape of a different kind that I have left behind. The 'body' of my experience may still be partly in the past, but my head is firmly located within the "Bearing Land", the present, the future, my home.

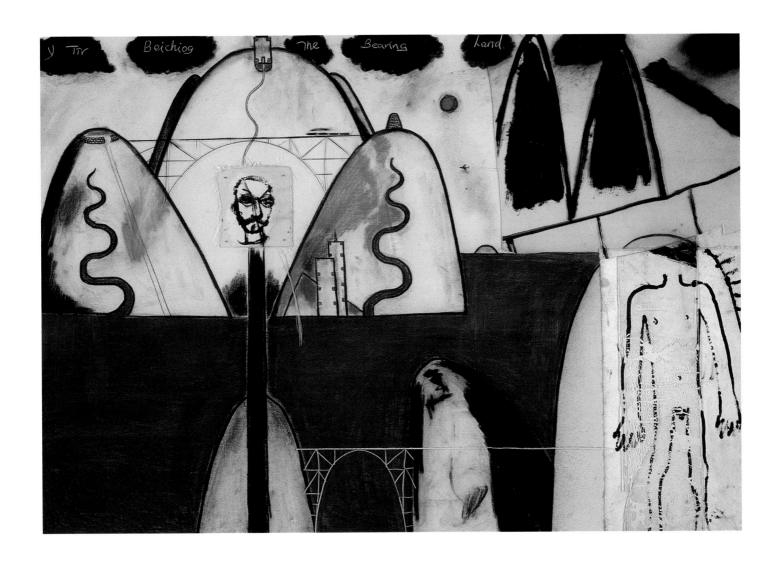

Hunan Mewn Tir Beichiog
104 x 144 cm
Pastel, emulsion and wax crayon on canvas and glass

KEITH BAYLISS

I admire those artists who claim to have control over every facet of the creative act, who know their starting place, the direction in which they move and the place at which they will arrive.

The journey that I take, no matter how well planned, leads me in directions that can please, surprise, confuse and disappoint. There is a point reached where the image being made appears almost to dictate its own direction and destination.

A dialogue takes place between the work and myself and as with all meaningful conversation each participant will alternate between being passive and dominant; ideas and gestures, serious and trivial, sad and happy, find themselves present in the same frame of time.

This visual dialogue is of course a dialogue with one-self. The final work will possess a life of its own, but its life is a mirror or window of my thoughts, opinions, desires, experiences and wishes.

In this way each work produced is a self-portrait, an intimate conversation revealed, explored and captured.

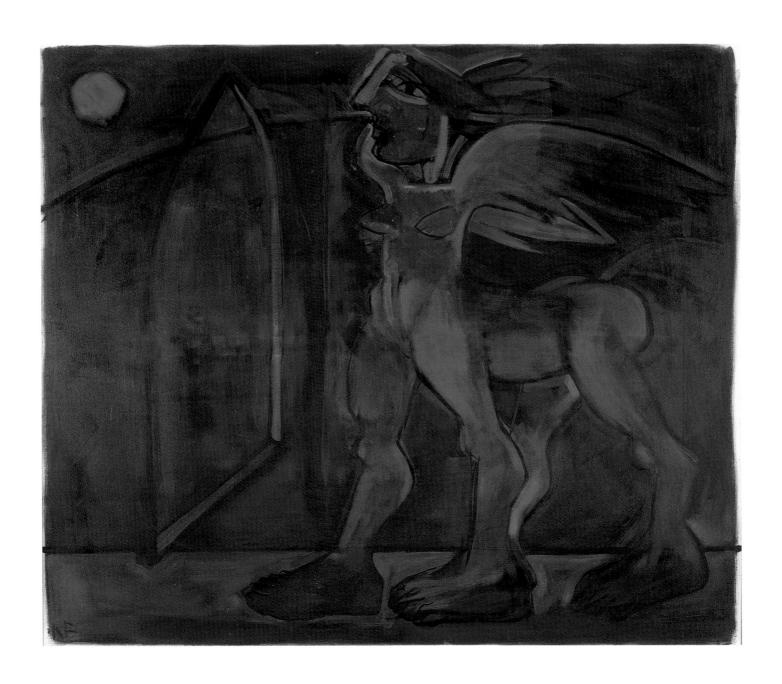

Untitled
153 x 184 cm
Oil on canvas

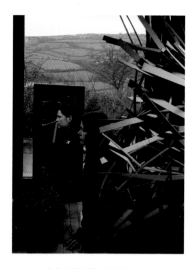

LYNNE BEBB

I live in rural South Wales on the slopes of the Gwendraeth Valley. The panorama which reaches deep into the countryside and then sweeps down to the sea, dominates my visual horizons. I am fascinated by its appearance, by the incidents which punctuate it and by the secret fabric of history, which has shaped each field, each hedge, each stone.

The patterns of human activity have been etched and sculpted onto the landscape for generations. I respond to the ebb and flow of change and continuity I see reflected there.

The valley slopes have been farmed since the Bronze Age. Every spring the fields are rolled, and so begins the harvesting of the grass which yearly paints the valley with colour and texture.

Images of the landscape adopt symbolic meaning, when represented in sculptural form, and bronze as a material resonates with the ancient history of its use, recalling other people in other times who were also makers.

I came to the valley as an adult. I have none of that nostalgia born of childhood intimacy, but still I feel the romance of others who have stamped the marks of their endeavours upon the landscape. I reach out and touch the past, and in doing so, I recognise myself in the traces that others leave. I too am present there.

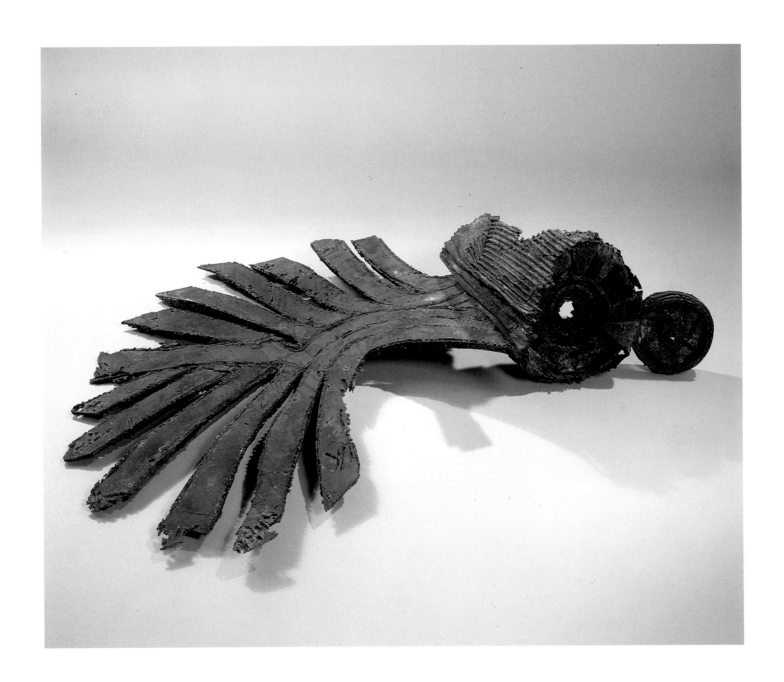

I too am present there
20 x 68 x 95 cm
Bronze

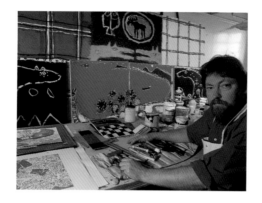

WILLIAM BROWN

"Just Like That" - Tommy Cooper
(British Comedian)

There are intense cultural resonances in the various forms of anthropomorphism. Loup-Garou, the spectre of the forest and bayou is common to Carib, Cajun and Canadian cultures. Here he is dressed in Tartan! The startling yellow and black one is in fact that of the McClures...... my own. His business is to patrol the human margins of the psyche and he serves here as both an intimate and self portrait. This identification with the animal was briefly and brilliantly expressed in a letter to Pierre Matisse from the Italian sculptor Giacometti in which he describes a sculpture of a dog:

"Un jour je me voyais. Dans la rue, un chien, sous la pluie. C'etait moi."

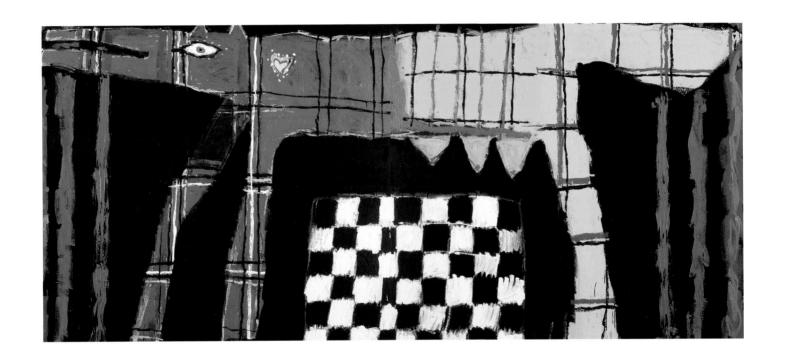

Hunan Mewn Tîr BeichiogLoup Garou
Diptych: each canvas 188 x 212 cm
Acrylic on canvas

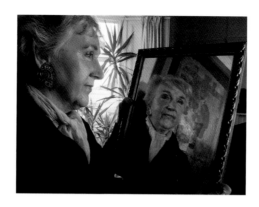

GLENYS COUR

And the story tells how "*Gwydyon can give Lleu no mortal wife, but only a flower girl*" - a woman made of flowers. And continues "*the love of Blodeuedd blooms and fades and has not the constancy of mortal feelings*". So, for her shortcomings, eventually Gwydyon turns Blodeuedd into an owl. Blodewedd still means owl in the language of our day.

As a student these words from the Mabinogion fascinated me and have continued to do so ever since. I have used this imagery many times over the years in various media and with different treatments - once many years ago as a mural. The mural, though I painted over it many times, continued to reappear. This must have been in some way significant.

Of recent years I have derived inspiration from the mystifying remains and artefacts of ancient civilisations. My obsession has been with gold - the material which doesn't corrode, but remains when great civilisations have disappeared. The gleaming beaten gold of Greek diadems, still trembling, as though made yesterday, the intricate convolutions of Celtic gold from Ireland, the richness of Byzantine decoration and Russian Icons - these are the stimuli for my work.

In my work generally I employ collage techniques and make my own paper in order to enrich surfaces. I stain with oil paint and gold pigment and apply gold leaf. So, in my treatment of the intimate portrait of Blodeuedd I hope to capture by these means something of the romance and richness of these tales and the mystery of this enigmatic, ancient figure.

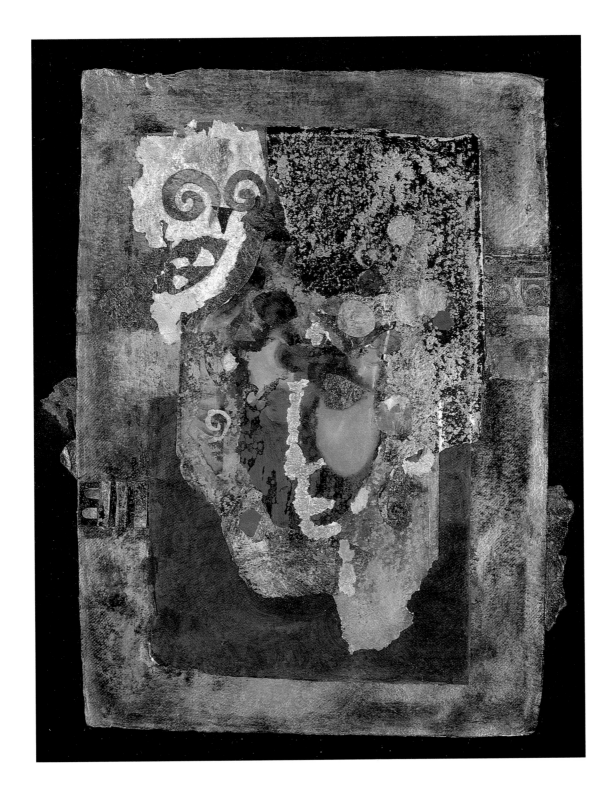

Blodeuedd
78 x 57 cm
Collage, handmade paper, mixed media

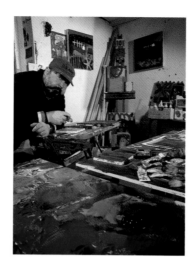

GARETH DAVIES

As a student, I was attracted to the work of the American artist Ben Shahn. When a few years ago my father went blind, I kept being reminded of a painting by Shahn titled 'The Blind Gardener' in which a man with grey hair and dark pools for eyes sits with his outstretched fingers tenderly encompassing an incredibly spiky cactus; a poetic juxtapositioning of images and ideas that still intrigues me. So this was the idea I originally had for the Intimate Portrait:- my father, a blind gardener...

However in 1994, and less that 5 months apart, both my parents died. I was devastated and felt that I had lost my 'past'. So my painting has become an attempt at focusing on the void left behind by death, on the remnants and souvenirs of someone's life:- an empty arm chair, a telephone that never rings, cactus plants left on a windowsill to die, things almost unbearable to look at. But the cactus lives. It thrives in adversity.

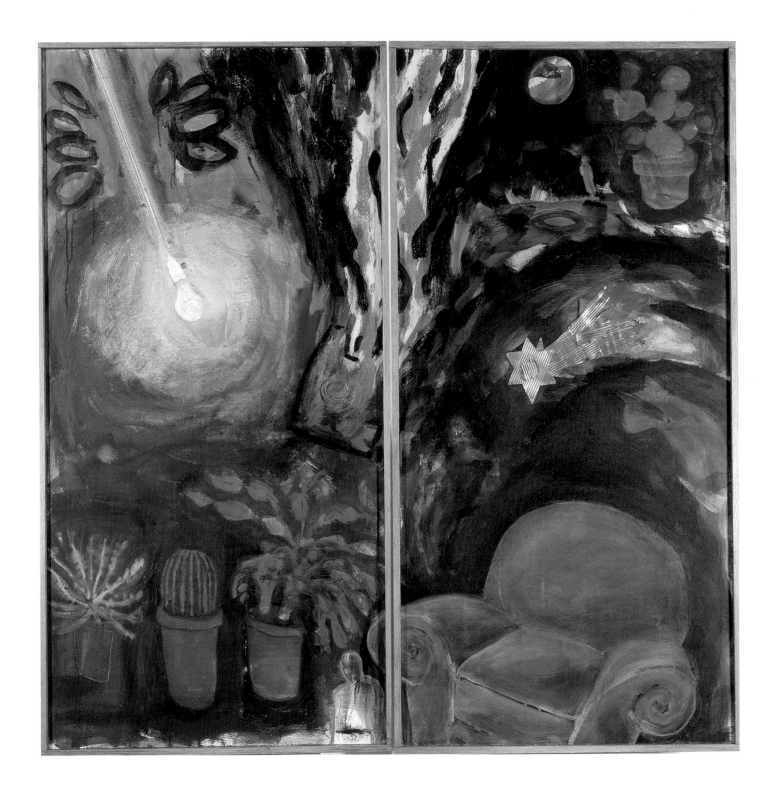

After the visit
Dyptich: each panel 123 x 61 cm
Acrylic and tin on MDF board

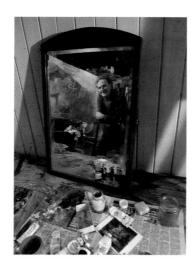

IVOR DAVIES

This portrait of Paul Davies (1947-1993) is intimate in showing details of his thoughts, ideas and actions. It is a psychological after-image of the most radical artist in Wales, perhaps in Britain, creating an art of Wales rather than art in Wales. He worked directly in public places with paint, sculpture, installations and performances such as the 'Welsh Not' (1977). The 'WN' was a punishment inflicted until the early twentieth century on children who spoke Welsh. The stigma remained. In this scene one of the nineteenth-century riders of the Rebecca movement, which destroyed the repressive toll-gate system, tramples on the pillory.

Picture a monumental composition, intimate details in varieties of dense paint, recalling some mysterious civilisation which expanded beyond Halstatt, Spain, Asia Minor to Ireland and Wales, unbroken for three thousand years. Deeply interested in his ancient celtic culture, Paul was now witnessing its destruction. Concerned with social and political issues, the disintegration of communities by settlers with a colonial outlook, second homes left empty and the refusal of the British government to recognise Welsh as an official language, Paul and his brother founded 'Beca' (a modern Rebecca group) in 1983.

In this portrayal, concealed in the glazes, scumbles and impastoes of red earth (mined at the military firing range at Brecon) there are layers of ideas and references; a metamorphism of the Celtic pantheon with Taranis, god of thunder; the early Welsh myth of Bendigeidfran's severed head; ancient heroes such as Arthur as well as the heroic modern activists Saunders Lewis, John Jenkins and Siôn Aubrey Roberts who, in my and many others opinion, is still wrongfully imprisoned.

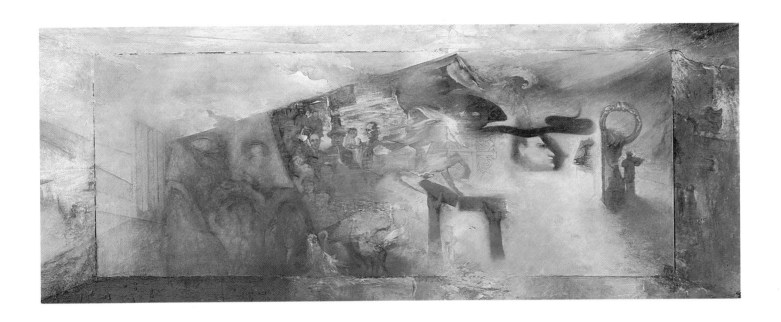

Beca
96 x 254 cm
Oil on canvas and plywood

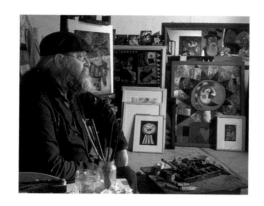

TONY GOBLE

A story-telling border person, between two lands, is unavoidably autobiographical. Born in Drenewydd, in the middle of Wales, I grew up with a taste for two tongues and a sense that things were not always what they appear to be: in the making of art there are no barriers, time blurs, the wake-a-day world is as real as the dream and the dream as real as visible facts.

Looking, as I work, from two points, the inner and the outer, the creative world of spirit and imagination makes rhythms with the world of material and form. The fragments of my life, the snap-shots of my dreams mix and the poem grows.

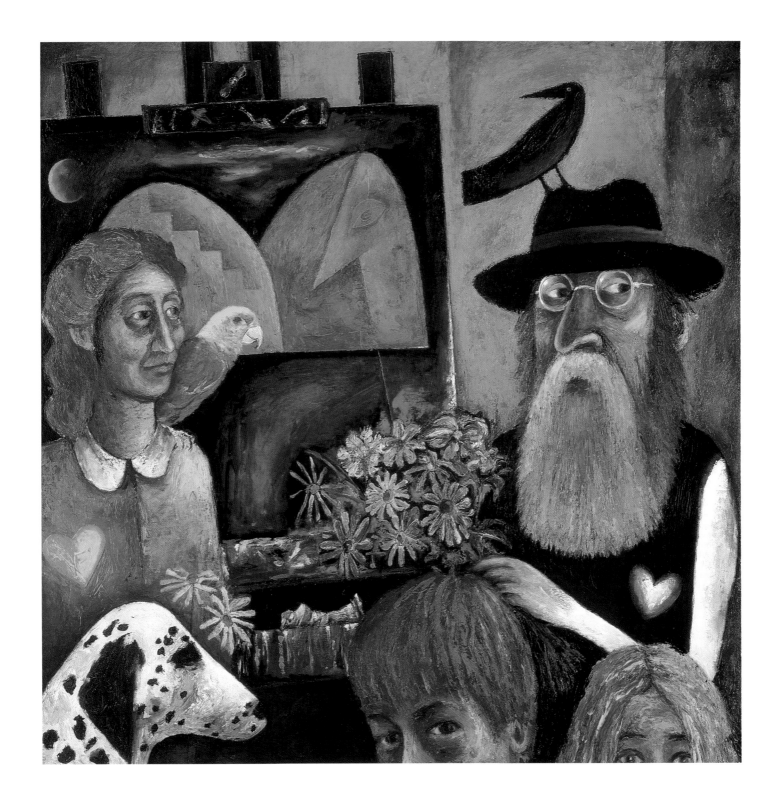

Flowers
122 x 122 cm
Oil on canvas

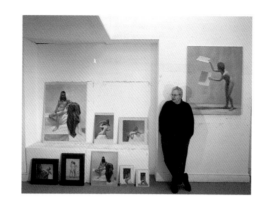

HARRY HOLLAND

Human beings are remarkable in all their aspects, not least their physical appearance. To find oneself alone in a room with a person whose reason for being there is to be looked at, is one of the strangest and most absorbing experiences that I know.

There are reasons, biological and social, why this should be so, but I am bound by the circumstances of being human, and have no wish to rise above it, just to step outside now and again, if I can.

Many aspects of character can be made the subject of visual comment. Composition, facial expression, dress, environment are all means of doing this, but in portraits which are done for study, as a private act, one is less interested in exercising these techniques for a particular end. Nor is state of mind of the sitter a prime consideration.

Rather I want to recreate the fact in front of me in such a way that communicates however partially, why it seems so extraordinary.

Something about the sitter always emerges from this process, which is more practise than depiction. Sometimes it is agreeable, sometimes not.

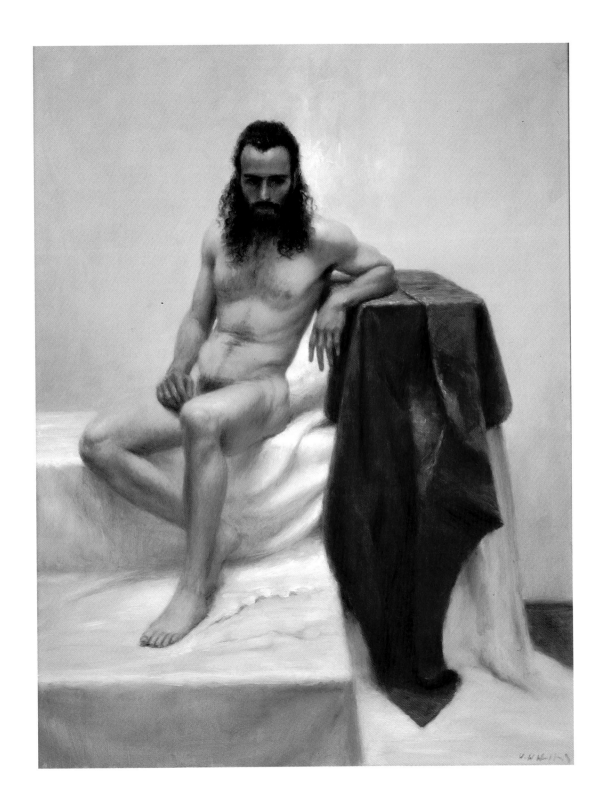

David
113.5 x 88.5 cm
Oil on panel

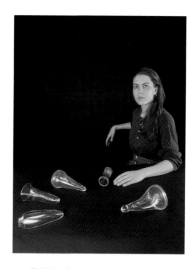

DEBORAH JONES

The subject of the work concerns the affirmation of a personal relationship - my relationship with the man I live with and love, the person who cooks the food we both eat together, the person who phones when one of us is out of town and whose smile is warm and generous.

The piece attempts to define the unique, the banal and often irrational feelings that comprise love - but in a non-linear way. Figuration can often probe the individual but not the context. By distilling and manipulating a few key elements of time, place and space this installation tries to locate a metaphor that goes beyond the purely personal and intimate details of the relationship.

Untitled
76 x 175 x 59 cm
Mixed media

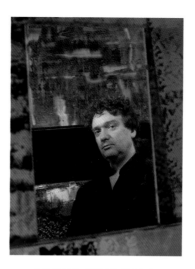

NIGEL MEAGER

When the Glynn Vivian Art Gallery invited me to paint an intimate portrait I went out to buy a mirror. I thought I might paint a self portrait. But I soon got bored and began painting on the mirror itself. I have always liked layering one colour on top of another. The mirror played tricks with the picture plane and the smooth glass allowed me to press, squeeze and drag very thin layers of paint across its surface. This gave the paint a kind of internal or back light. There is still some of the effect just visible in the finished painting.

But what does making a painting like this mean? It is easy to make quick judgements about someone you meet for the first time. First impressions count for a lot. But in getting to know a person better one can uncover many layers of personality and many surprises. Getting to know a painting can be a similar experience.

In this painting the mirror reflection of myself was soon obscured as layer after layer of colour skimmed across the surface of the glass. The appearance hides many layers. If you have time to get to know the portrait perhaps you will have time to look beyond and into the surface and perhaps become a little intimate with it. But without question there is always much that remains hidden.

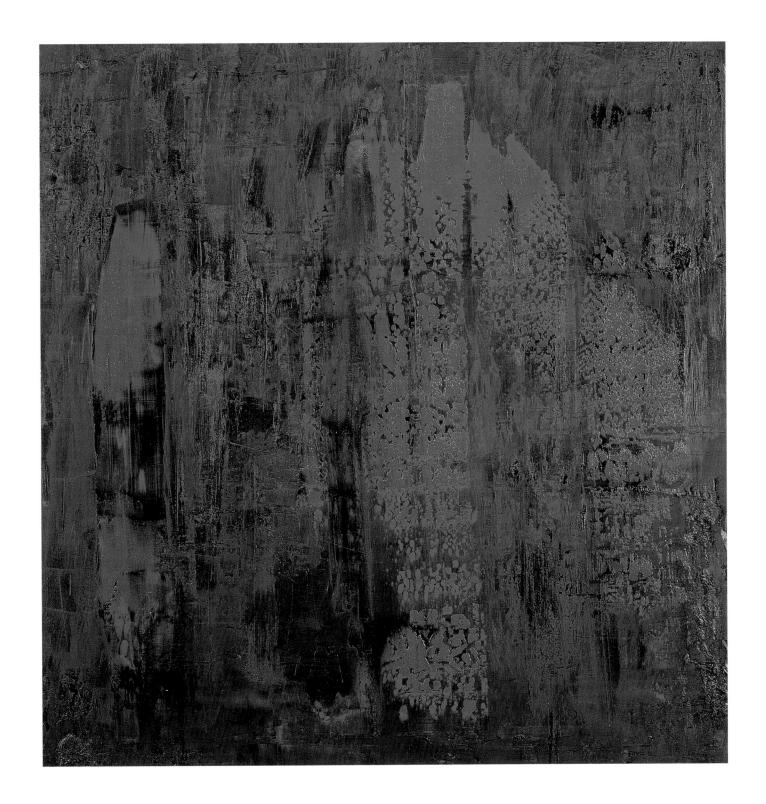

Self portrait 15.2.95
102 x 100 cm
Oil on mirror

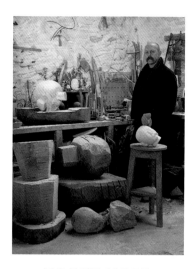

ROGER MOSS

INTIMATE PORTRAIT
INTIMATE THOUGHTS
INTIMATE SCULPTURE
INTIMATE SCALE
INTIMATE QUALITIES
INTIMATE PORTRAIT
DREAMING

dream (driːm) *n.* **1.** mental activity, usually in the form of an imagined series of events, occurring during sleep. **2.** a sequence of imaginative thoughts indulged in while awake; daydream; fantasy. **3.** a person or thing seen or occurring in a dream. **4.** a cherished hope; ambition; aspiration. **5.** a vain hope. **6.** a person or thing that is as pleasant, or seemingly unreal as a dream.

intimate[1] ('ɪntɪmeɪt) *adj.* **1.** characterised by a close or warm personal relationship. **2.** deeply personal, private, or secret. **3.** *Euphemistic.* having sexual relations (with). **4.** having a deep or unusual knowledge (of). **5.** having a friendly, warm or informal atmosphere. **6.** of or relating to the essential part or nature of something; intrinsic.

intimate[2] ('ɪntɪˌmeɪt) *vb.* **1.** to hint; suggest. **2.** to proclaim; make known [C16: from Late Latin *intimāre*].

portrait ('pɔːtrɪt, -treɪt) *n.* **1.** a painting, drawing, sculpture, photograph, or other likeness of an individual, esp. of the face. **2.** a verbal description or picture of a person's character. [C16: from French, from *portraire* to PORTRAY].

quality ('kwɒlɪtɪ) *n.; pl.* **-ties. 1.** a distinguishing characteristic, property, or attribute. **2.** the basic character or nature of something. **3.** a trait or feature of personality.

thought (θɔːt) *vb.* **1.** the past tense and past participle of **think.** ~*n.* **2.** the act or process of thinking; deliberation, meditation, or reflection. **3.** a concept, opinion or idea. **4.** philosophical or intellectual ideas typical of a particular time or place. **5.** application of mental attention; consideration. **6.** purpose or intention.

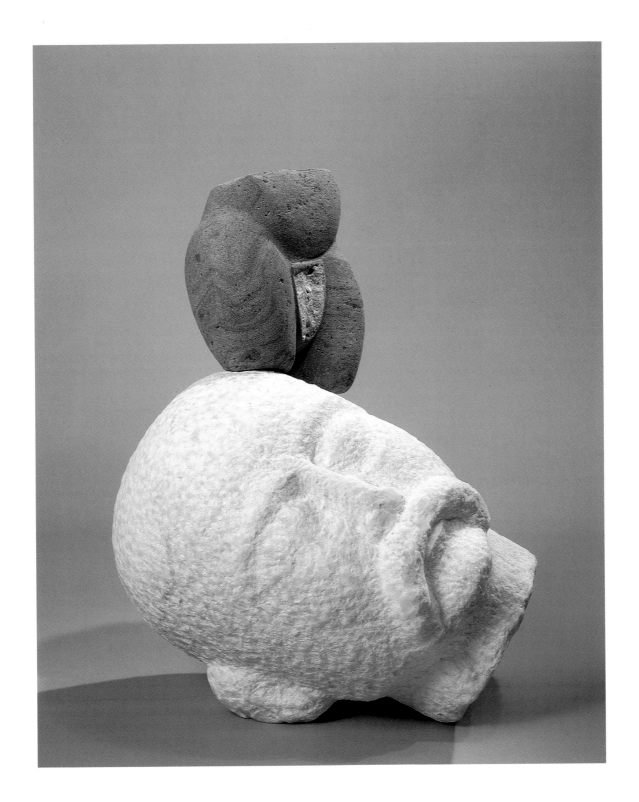

Intimate Portrait: Dreaming
30 x 25 x 18.5 cm
Marble, terracotta (brick)

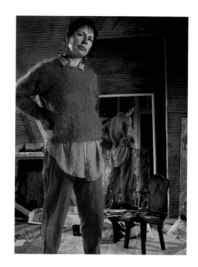

CHERRY PICKLES

Looking afresh at my 'Intimate Portrait' paintings it strikes me that it may be characteristic of my approach to self-portraiture as a genre that all three contain obscure landscapes in portrait format: one fictitious, in a jersey design; one real, observed through a hole in the studio wall; and one reflected in a real pair of dark glasses.

I need the irresponsible excitement of de-stabilising the perceived restraints of the genre I am working in.

Paintings of women scrutinised alone, especially when partly undressed, traditionally provoke questions of morality, beauty and sexual availability.

In these paintings I try to subvert these responses.

I liked the awkward, ridiculous pose in *Landscape Jersey* and wanted to make it monumental. It is something you can only really do in a self portrait. It is unlikely that a man would ever make a woman look ridiculous in this way.

In my self portraits the face, the traditional focus of the painting, is obscure or obscured. You are denied the sort of information you expect from a portrait.

The figures in *Vyrnwy* and *Landscape Jersey* are like furtive animals caught out in some dubious activity - like Eve - but the leaf covers the face rather than the genitals. They are clearly guilty, but of what?

In *Vyrnwy* the composition is awkward like the pose. It is as difficult in the painting as in real life to look at the hole in the wall and the lion's head together with the mirror. The light on the studio wall seemed more of a solid entity than any of the visible physical objects, and threatens to override the drawing of the space in the mirror.

My most recent work shows an increasing preoccupation with the visual corruptions that looking through a looking glass or at reflective surfaces introduce, most clearly evident here in *Mykonos*.

In all these paintings the meticulous accuracy of position and space, together with the casual, almost slovenly, application of some of the paint, is part of the emotional subject of the painting and is tellingly autobiographical.

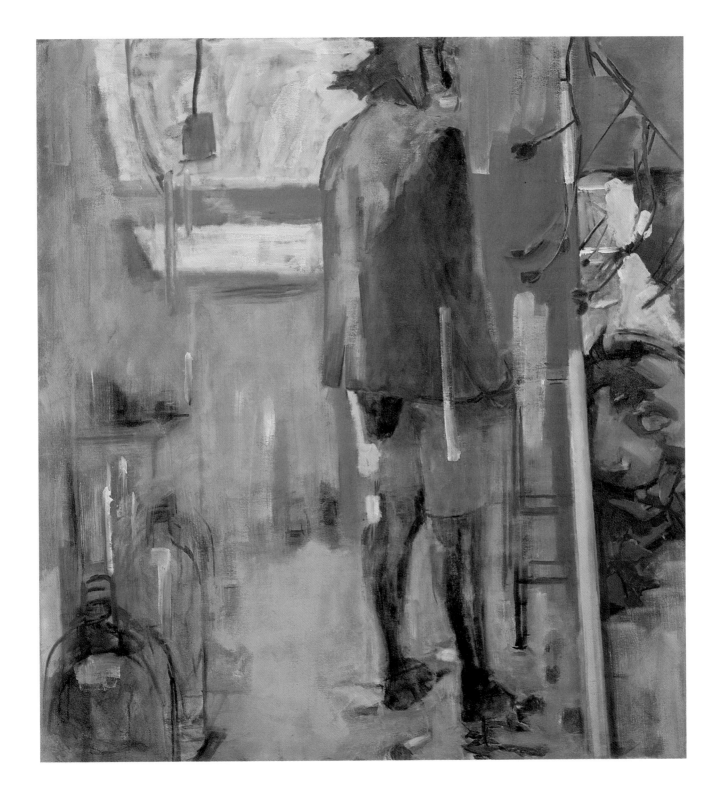

Vyrnwy Self Portrait
137 x 127 cm
Oil on canvas

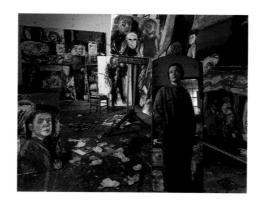

SHANI RHYS JAMES

I'm not interested in straight portraiture as a genre as the paint quality is often sacrificed to portray the sitter. Often I paint self-portraits, myself in the studio surrounded by the studio debris, the figure either caught in the mirror as if trapped or standing amongst a sea of gloves. The self portrait is a means to get inside my own head. A portrait of someone requires the same procedure.

Francis Bacon succeeds in expressing more than just a portrait in his paintings, as does Freud's recent naked self-portrait. They have aspired to the quality of Rembrandt, Van Gogh, Soutine and Cézanne.

In 'The Purple Room' I have portrayed a space from my memory, but in the execution evolved it into an imaginary room in which the floor boards have been exaggerated; there wasn't such a bed; the bed is covered in the yellow which is used in the miniature theatre. The scale of the painting seemed essential when I thought of the 'intimate portrait' because I hope the viewer may feel he/she may walk into the room.

In a sense all my paintings are 'intimate portraits' where the eye contact with the viewer draws you in.

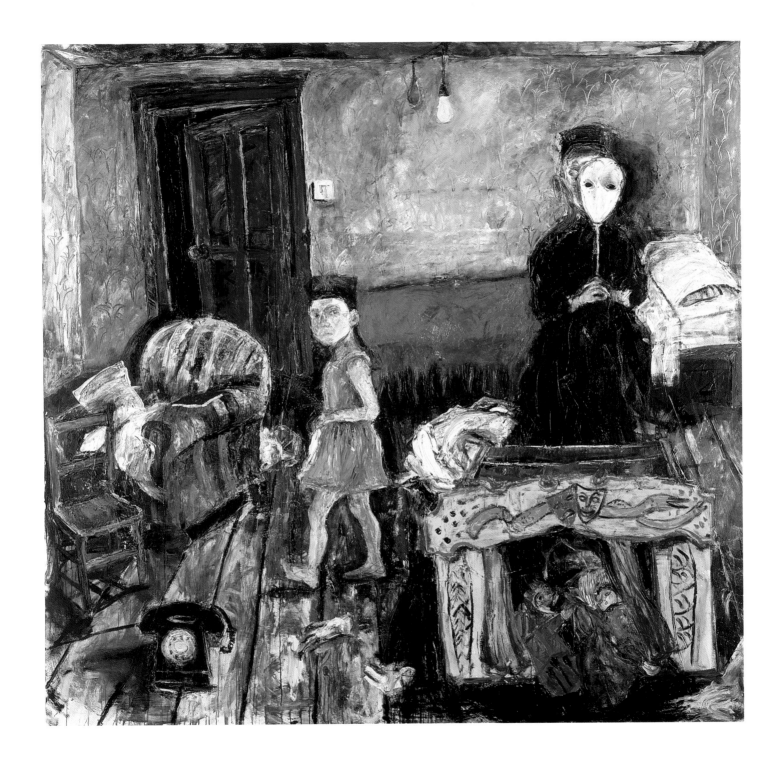

The Purple Room
244 x 259 cm
Oil on canvas

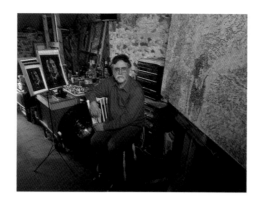

JEFF SPEDDING

The subject of my painting is a photographic image of my wife Sally Spedding in a swimming pool.

What makes it an intimate portrait to me is my wife's involvement, of course, and that the pool is situated very near to our home in South West France. But the real subject of the painting is a photographic image, and it is this link between the two, via my responses, which I find most intimate.

My painting is an attempt to experience in a more intense and heightened way, the particular photograph in front of me. Through this intimate and private process, I try to create some kind of visual order and optical sense to formal relationships I feel are already inherent, if not realised, in the photograph.

I am trying to convey varying levels of experience of intensity and disintegration of forms, which are appropriate to their nature and role, as presented to me through the photograph. My ultimate aim, as far as I can understand it, must be to give expression to my responses by the integration and balance of these elements, through composition. In other words, to find myself through a most sane and very intimate activity.

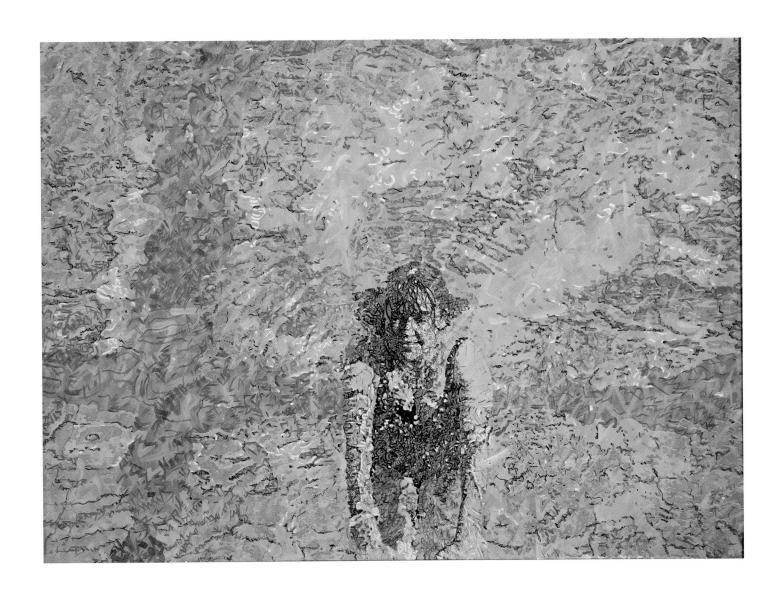

Naguese

91.5 x 126.5 cm

Oil on canvas

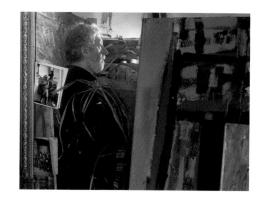

JOHN UZZELL EDWARDS

My first painting was of my mother.

It was called "Why can't you be like our Maggie's boy?".

But I could not be like Maggie's son. I had to paint. And so the fight began – the struggle against family ties and expectations, at the same time a recognition of those links which bind me to the industrial past, and to the far-off, dark and war-like fight for life and freedom.

My canvas is Wales: **carnivals** on grassless fields, rugby wives in windswept tulle and mud and tinsel boots, with sharp tip-hills behind; skirted ladies' choirs, the strikers' bands of '26 – our grey and glamorous occasions when we seek comfort in numbers, when we mask and pose. Always the volatile balance between desperate humour and tragedy.

The language of my newest paintings comes from my passion with the Celtic visual tradition, the meanderings of medieval manuscripts, carved standing stones, and **warriors.**

But – above all this – my almost war-like struggle in the search for colour, and form, and powerful rhythms – the struggle with the creative process itself.

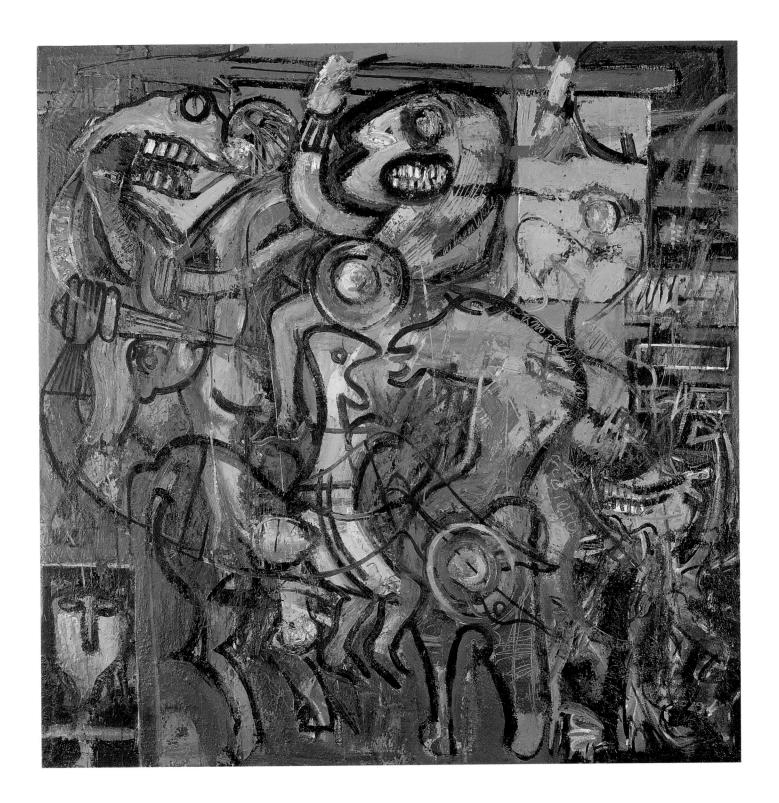

Carnival
180 x 181.5 cm
Oil on canvas

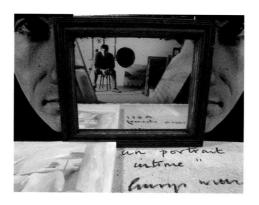

EMRYS WILLIAMS

We all have our own mental image of what form an intimate portrait might take; mine would be a gouache on brown card by Bonnard or Vuillard, a head modelled in paint by Gwen John, or a figure glimpsed through a gateway, gently catching the light, in a Dutch or Flemish genre painting. These generalised mental images perhaps played some part in my response to the project.

All painting has to work in a way that might be described as 'intimate' - whether it be a large scale heroic painting or Mondrian's geometry. To me intimacy requires focus and a tactile richness - qualities that go far beyond the object of attention.

In my work images of the seaside are repeated and developed, creating a self-portrait that is implied through changes in viewpoint. The pictures portray imaginary walks and journeys; figures are glimpsed through the shelter windows, sailboats pass - the viewer is placed in different spatial positions witnessing fragmentary events in a visual diary.

In the work for the exhibition my original mental image of what portrayal and intimacy might mean influenced the size and subject of the picture. I tried to portray a moment and within this locate a snatched appearance, a tiny memory of a glimpsed figure, a touch of life and warmer colour in a cool environment.

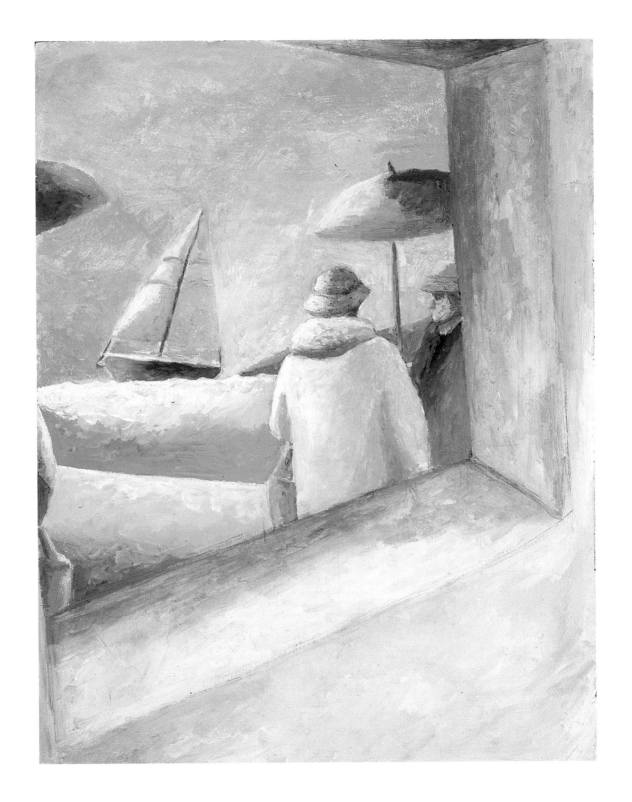

Un Portraite Intime
25.5 x 20.5 cm
Acrylic on panel

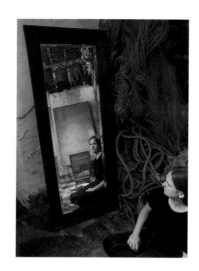

LOIS WILLIAMS

The work is about an imagined person who lives in a place which is 'home' – the rock, the 'earth'-filled bowl, the unpolished cupboard – but who thinks of journeys for which sophisticated accessories - the hat box, the brass-handled case - would be desired accoutrements. She may or may not make these journeys, take these routes.

In my student days I heard a quotation which has stayed with me ever since :

"All my works are but fragments of a single self portrait".

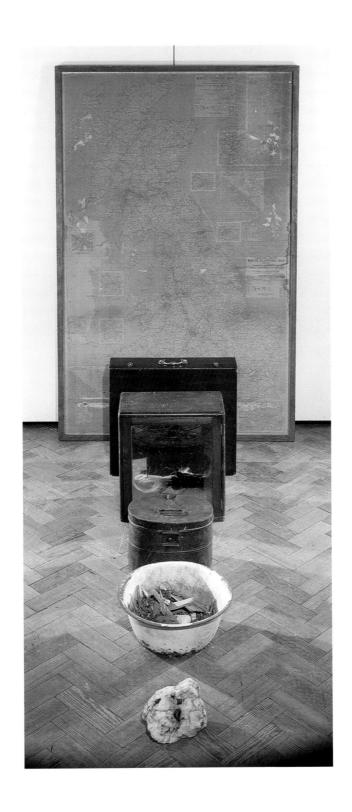

Routes
Map 163 x 96 cm (plus other objects)
Mixed media

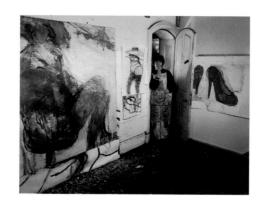

SUE WILLIAMS

Throughout my work, the investigation of drawing proves to be an immediate and easily resourced medium with which I can produce images. Thus drawing and mark making are of the utmost importance in my work. I have allowed to increase in potency the image of the figure as a subject, human emotions, body language and signs interpreted through action. I am looking at ideas concerning two figures in the arena of a canvas; figures as an event in space and time which enables a sensation of memory and thus allows imagination to function.

This particular image portrays the reunion of two people - the sisters - a personal observation of a particular relationship.

My present on-going subject matter is a response to personal experiences combined with fantasy expressions of mood – an analytical biography, a visual monologue.

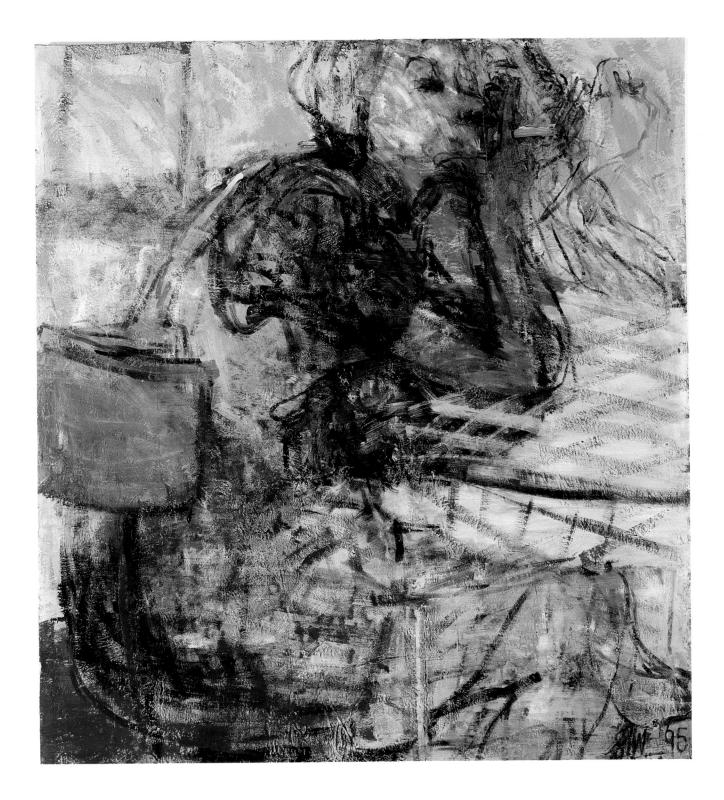

Re-union
165 x 153 cm
Oil, wax, collage on canvas

NIGEL WOOD

There is surely a timeless fascination for artists to represent others. Certainly for me, the human head and face have always been compelling subjects.

I work from life, and in the case of a portrait, enjoy working co-operatively with another person. The contribution of the model is very important – it helps greatly if the person is responsive to painting, can commit him or herself to the work, and remain to some extent animated while motionless and mostly silent.

For me the intimacy of the portrait has much to do with learning to let go of my precon- ceptions and thus see more deeply. Although I try to be detached, I am very much present in my work. The relative success of a portrait depends on it containing, not only individual qualities of the subject and of the artist, but also qualities which resonate with humanity as a whole.

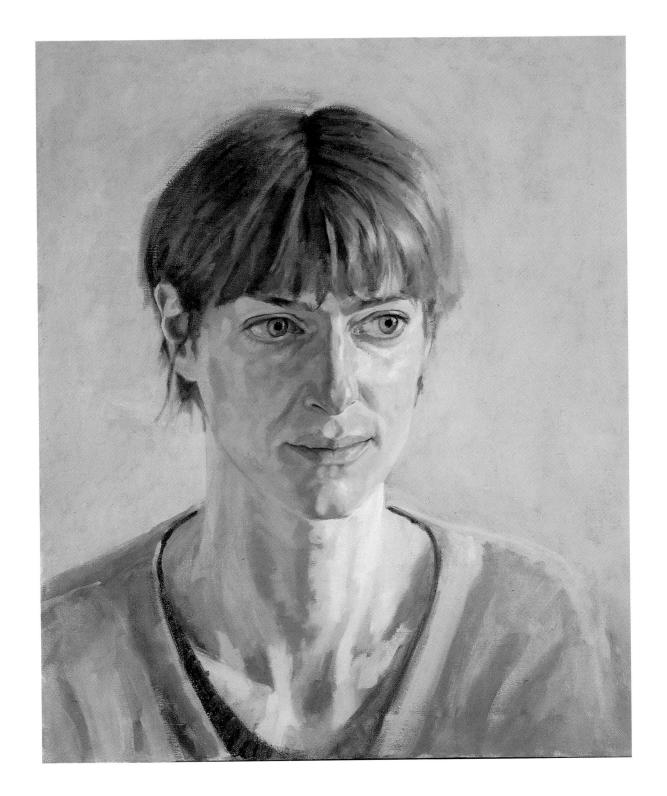

Rachel
65.5 x 56 cm
Oil on canvas

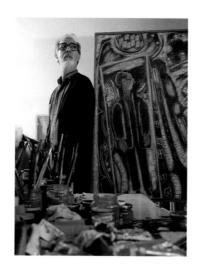

ERNEST ZOBOLE

Over the last few years my painting, which has been about the place where I live essentially, has included figures representing myself. The figures are not thought of as portraits. The place is what interests me and when painting I think of being within the landscape, surrounded by it, rather than at some vantage point looking at a view of it. Representing myself in the painting probably has something to do with this.

For the painting on show the figure is much larger than I would have thought of doing and possibly begins to constitute a portrait.

Of the formal concerns when working, one of the main ones this time was the problem of trying to make the drawing of the figure and the drawing of the rest of the painting fit together.

Having been occupied with the struggle of the painting and trying to arrive at some sort of result, I have no idea what kind of portrait it is, or whether I would want to consider the portrait part as being separate from the rest of the painting. What I can say is that I have put myself in a painting surrounded by my subject matter.

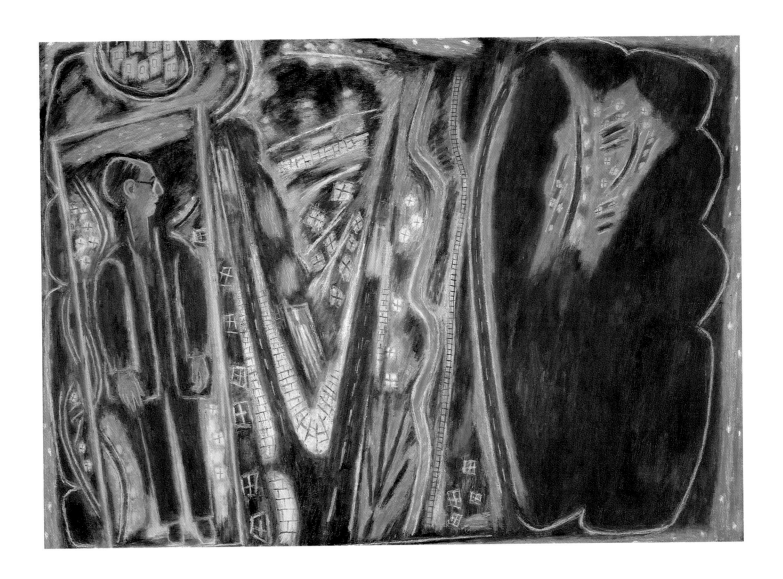

A painting about myself in a landscape
167 x 116 cm
Oil on canvas

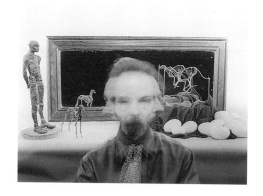

GRAHAM MATTHEWS

When asked to make thirty one portraits of people I had never met or barely knew (and I have yet to meet no. 31) it seemed to emphasise the notion that "photography is a faked medium" – especially as these photographs were for the exhibition 'Intimate Portraits'.

I've always been interested in the narrative of photography, choosing to reflect images of the artists inserted amongst their materials in their studio, and combine visual references in the portraits of writers within these contrived parameters.

My own 'Intimate Portrait' went beyond the insignificance of a self-portrait to contain maquettes, 'three dimensional sketches', by my wife which symbolise some of the elements in my life that are important and intimate.

The subjects in the portraits in this exhibition represent a small selection of society who express their feelings through their works. I wonder what I would choose as an 'Intimate Portrait' of an eighty-two year old countryman I know who is a 'Master Stone Mason' – are the walls he has built, both castle and field, to be found as witness to his 'decisive movement'?

ACKNOWLEDGEMENT

All photography by Graham Matthews;
original photograph of Emrys Williams (see p.60) by Jonty Wilde.